BIOGRAPHIC
CÉZANNE

O9-BHI-605

KATIE GREENWOOD

AMMONITE
PRESS

First published 2017 by
Ammonite Press
an imprint of Guild of Master Craftsman Publications Ltd
Castle Place, 166 High Street, Lewes, East Sussex, BN7 1XU,
United Kingdom
www.ammonitepress.com

ISBN 978 1 78145 310 0

Publisher: Jason Hook
Concept Design: Matt Carr
Design & Illustration: Matt Carr & Robin Shields
Editor: Jamie Pumfrey
Consultant Editor: Dr Grant Pooke

Colour reproduction by GMC Reprographics
Printed and bound in Turkey

PICTURE CREDITS: AKG Images: 42T, 65B; Album/Oronoz: 46–47.
Alamy/Archivart: 68; Art Collection 2: 67; Maurice Babey: 82; Josse
Christophel: 43. Getty Images/DeAgostini: 54T. J. Paul Getty
Museum. Digital image courtesy of the Getty's Open Content
Program: 60. The Metropolitan Museum of Art: 28, 39, 42B, 49, 54B,
55T, 55B, 64T, 64B, 65T. National Gallery of Art, Washington: 19, 74.

CONTENTS

ICONOGRAPHIC

WHEN WE CAN RECOGNIZE AN ARTIST BY A SET OF ICONS, WE CAN ALSO RECOGNIZE HOW COMPLETELY THAT ARTIST AND THEIR WORK HAVE ENTERED OUR CULTURE AND OUR CONSCIOUSNESS.

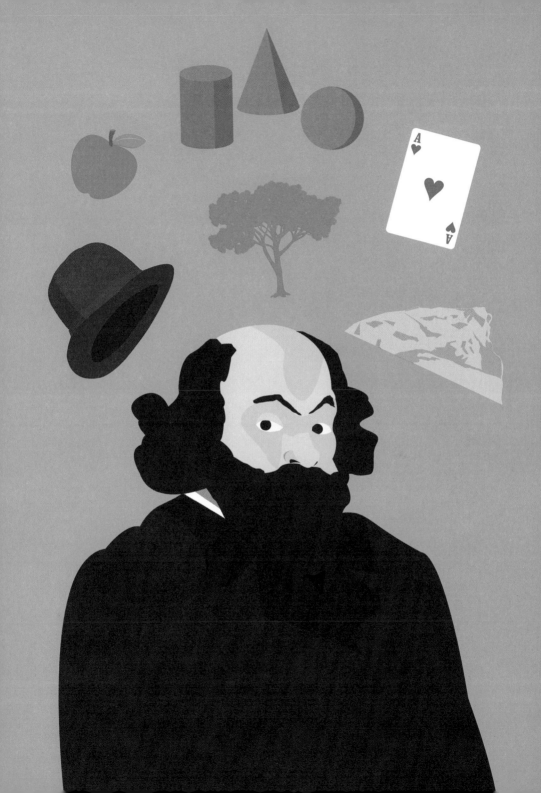

INTRODUCTION

Paul Cézanne was concerned with the very fundamentals of painting: colour, form, depth and surface. His quest to interpret the essential nature of his subjects and the geometry that underpinned them – from a majestic pine tree to the humble sugar bowl – would come to predict the radical new forms of art that emerged in the early years of the 20th century, such as Cubism. His unique vision was greatly admired by his fellow painters and was hugely influential for his successors.

In 1907, artist Maurice Denis named Cézanne 'The Master of Aix', posthumously referencing his painterly status as well as the strong connection to the land of his birth. During childhood, Cézanne roamed the countryside of his cherished Provence and developed a love of the classics during his studies. As a mature artist he spent extended periods painting the landscape in isolation, seeking to harmonize his canvases in the way he witnessed in nature. Provence became Cézanne's personal Arcadia, and provided him with the greatest motifs of his career – including his beloved Montagne Sainte-Victoire.

"IN ORDER TO MAKE PROGRESS, THERE IS ONLY NATURE, AND THE EYE IS TRAINED THROUGH CONTACT WITH HER."

—Paul Cézanne, letter to Émile Bernard, 25 July 1904

However, it was Paris that first brought him into contact with other painters seeking to overturn the established view of art. They included Édouard Manet, Claude Monet, Auguste Renoir and most importantly Camille Pissarro. Pissaro was the lynchpin of the Impressionist circle and the artist that would have the greatest impact on his life and work.

Comparing paintings from the opposite ends of Cézanne's career presents stark contrasts. Early works include darkly coloured and thickly painted portraits, still lifes, and visions of murder, abduction and sexual fantasy. These images of conflict and desire sit somewhat strangely with his celebrated later work, which is imbued with colour and a sense of harmony. It was Pissarro who encouraged a lightening of his colour choices and the marks upon his canvas, with landscapes becoming his principal subject. Cézanne exhibited twice with the Impressionists – in 1874 and 1877 – impressing his peers if not the critics with his talent.

Increasingly, Cézanne would concentrate on the underlying structure of things, moving on from his youthful approach and the influence of Impressionism to form a new language in art, created in dialogue with the natural world. Nature provided Cézanne with a constant, something that cannot be said of some of his personal relationships. His friendship with Émile Zola was fractured following the publication of a novel he regarded as a personal slight, and he became estranged from his wife, Hortense, when they were finally married several years after meeting each other and having a son.

A series of frustrations plagued Cézanne throughout his life. In his teenage years, it was his desire to travel to Paris, and though encouraged by his friend Zola, it was forbidden by his father. While establishing his reputation as an artist, he suffered critical rejection and spent many years on the fringes of the Paris Salon. In old age, it was the pursuit of artistic perfection in the face of illness that was his main source of anguish. In the end, his visionary works – unified by a constructive brushstroke, geometric composition, harmonious colour palette and an abandonment of traditional perspective – saw him enjoy critical and financial success during his lifetime and helped form a lasting legacy in the history of art.

"MY AGE AND HEALTH WILL NEVER ALLOW ME TO REALIZE MY DREAM OF ART THAT I HAVE BEEN PURSUING MY WHOLE LIFE."

—Paul Cézanne, letter to Claude Roger-Marx, 23 January 1905

PAUL CÉZANNE

01
LIFE

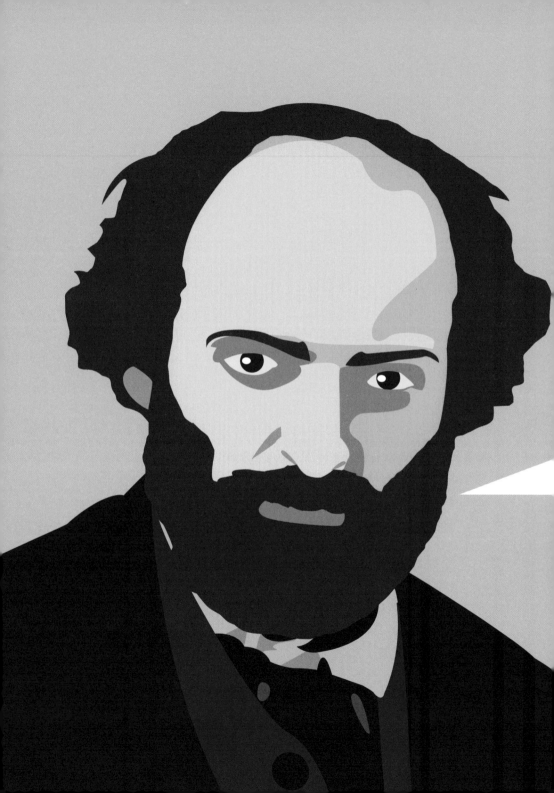

"THE ARTIST IS ONLY A RECEIVER OF SENSATIONS, A BRAIN, A REGISTERING MACHINE ... A GOOD MACHINE OF COURSE, FRAGILE AND COMPLEX, ESPECIALLY IN RELATION TO OTHERS."

—Paul Cézanne, quoted in *Cézanne* by Joachim Gasquet, 1921

PAUL CÉZANNE

was born on 19 January 1839 in Aix-en-Provence, France

The countryside surrounding his sleepy provincial hometown, situated on a plain overlooking the Arc River, was the young Cézanne's playground. In 1861, Cézanne travelled to Paris to pursue his art, but the pull of his native Provence was too strong. After seasonally migrating between the capital and the land of his birth, he would resettle in Provence at the age of 47, drawing on his deep affinity with the region's landscape to produce his most monumental works.

◀ Also born in Aix: **Achille Empéraire** (1829–98), friend and fellow painter

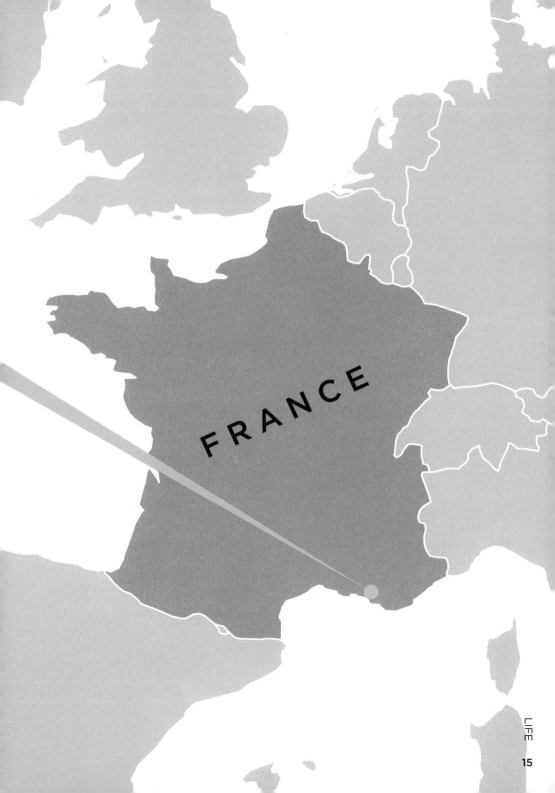

FRANCE

THE WORLD IN
1839

JANUARY
In France, Louis Daguerre takes the first photograph of the moon.

JANUARY
The first tea from India arrives in the UK.

OCTOBER
Sharif Abdelkader El Djezairi of Algeria declares jihad on French colonial forces.

At the start of 1839, Louis Daguerre (right) pointed his camera at the night sky and took the first ever photograph of the moon. Horizons were widening and advances in telecommunications would begin to bring the world closer together. Colonial expansion continued apace, with British forces capturing Hong Kong, following trade tensions with China, and the 'Great Game' between Britain and Russia was played, with a prize of winning influence in Central Asia at stake.

APRIL

Belgium is declared an independent kingdom after the signing of the Treaty of London.

MARCH

Prussia limits a child's working week to 51 hours.

NOVEMBER

Oberto, Conte di San Bonifacio, Giuseppe Verdi's first opera, opens in Milan.

JUNE

The First Opium War is triggered after Chinese officials burn 1,000 tons of the drug, seized from British traders at Humen.

JULY

In the First Anglo-Afghan War, British forces capture Ghazni, Afghanistan.

AUGUST

Hong Kong is seized by the British from China.

GRANDFATHER
Thomas François
Xavier Cézanne
(1756–1815)

GRANDMOTHER
Rose Rebuffat
(1761–1821)

FATHER
Louis-Auguste Cézanne
(1798–1886)

WIFE
Marie-Hortense Piquet
(1850–1922)

Paul Cézanne
(1839–1906)

SON
Paul Cézanne
(1872–1947)

THE CÉZANNES

Cézanne's father Louis-Auguste was a self-made man, born in Saint-Zacharie, northeast of Marseille. He trained as a hat-maker in Paris, following in the artisanal footsteps of his father Thomas (a costume tailor) and grandfather André (a master wigmaker), setting up the outlet 'Cézanne and Coupin' in Aix in 1825. Louis-Auguste met Élisabeth while she was working as his employee and the couple lived together out of wedlock for six years, from 1838 until they were married in 1844. During this time Paul and his sister Marie were born, and their younger sister, Rose, arrived in 1854. Louis-Auguste turned to finance and the 'Cézanne and Cabassol' bank was inaugurated in 1848, prospering and making him rich before being dissolved in 1870.

GRANDFATHER
Joseph Claude Aubert
(1776–1828)

GRANDMOTHER
Anne-Rose Girard
(1789–1851)

MOTHER
Anne Élisabeth
Honorine Aubert
(1814–97)

SISTER
Rose Conil
(née Cézanne)
(1854–1909)

SISTER
Marie Cézanne
(1841–1921)

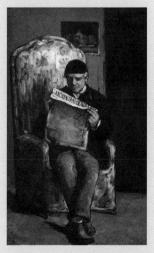

▶ *The Artist's Father, Reading "L'Événement"*
Paul Cézanne
Oil on canvas, 1866
78 x 47 inches (199 x 119 cm)

1839

Paul Cézanne is born on 19 January in Aix-en-Provence, in a charitable institution on the Rue de l'Opera.

He is baptized at the Church of Sainte-Marie-Madeleine on 22 February.

1841

His sister Marie is born.

1844

His parents Louis-Auguste and Élisabeth marry on 29 January, shortly after his fifth birthday.

1858

On his father's wishes, Cézanne enrols at law school, though he also enquires about the École des Beaux-Arts in Paris.

Émile Zola leaves Aix for Paris and the two maintain correspondence.

1860

Cézanne is despondent after his father forbids him to abandon his law studies and travel to Paris until he passes his exams.

1859

His father acquires the country estate Jas de Bouffan for 85,000 francs.

1848

Louis-Auguste opens the 'Cézanne and Cabassol' bank with partner Joseph Cabassol.

1849

The Musée d'Aix receives a bequest from the artist François-Marius Granet. The works will come to supply the young Cézanne with inspiration.

1850

After attending his local public school, Cézanne enrols at the Catholic school of Saint-Joseph, where he makes friends with Henri Gasquet.

1857

Cézanne enrols at the École Gratuite de Dessin ('free drawing school') in Aix. He studies life models and classical sculpture under the instruction of Joseph Gilbert.

1854

His sister Rose is born.

1852

He enters the College Bourbon, meeting Émile Zola and Baptistin Baille.

THE THREE INSEPARABLES

Cézanne met Émile Zola and Baptistin Baille while studying at the Collège de Bourbon. They formed a close-knit trio that would become known as 'The Three Inseparables'. Together they hunted, fished and swam in the River Arc. They read Homer and Virgil (Cézanne excelled in the classics), wrote plays and poetry (sometimes in Latin), debated art and carried out scientific experiments. When Zola left for Paris in 1858, the halcyon days of youth were left behind, though they would maintain a devoted friendship until the publication of Zola's novel *L'Oeuvre* in 1886.

PAUL CÉZANNE
PAINTER
1839–1906

ACTIVITIES INCLUDED:

ÉMILE ZOLA
WRITER
1840–1902

BAPTISTIN BAILLE
SCIENTIST
1841–1918

PURSUING ART

1865
His submission is rejected by the Paris Salon. He will not be accepted for another 17 years.

1872
Cézanne and Hortense have a son, Paul, and are living in Auvers-sur-Oise in the suburbs of Paris. Cézanne works with Camille Pissarro.

1861
Cézanne spends several months in Paris, meeting Camille Pissarro while studying art at the Académie Suisse. He is rejected from the École des Beaux-Arts and returns to Aix to work in his father's bank.

1870
The Franco-Prussian War begins. Cézanne evades military service.

1860

1865

1870

1862
Cezanne establishes himself in Paris.

1866
He befriends Claude Monet (below) and Auguste Renoir at the Café Guerbois.

1869
He meets Marie-Hortense Fiquet. Their relationship will remain a secret from Cézanne's father for the next nine years.

1863
Cézanne receives permission to copy at the Louvre. He finds affinity with the work of Poussin and Delacroix, and exhibits at the Salon des Refusés.

1874
Cézanne exhibits three works in the First Impressionist Exhibition and receives harsh criticism.

1877
He exhibits 16 works in the Third Impressionist Exhibition. He will not exhibit widely again until his first solo show in 1895.

1882
Renoir (right) and Cézanne work together for a fortnight in L'Estaque. Cézanne exhibits at the Paris Salon for the first and only time.

1879
Cézanne is living in Melun, just south of Paris.

'5

1880

1885

1890

1881
A studio is built at his father's estate, Jas de Bouffan, in October.

1886
Zola publishes *L'Oeuvre*, basing the character of an unsuccessful artist on Cézanne, and Cézanne severs their friendship. He marries Hortense in April. Cézanne's father, Louis-Auguste, dies in October, leaving him a substantial inheritance.

1878
His father limits his regular allowance after discovering his relationship with Hortense. Émile Zola helps to support Cézanne and his young family.

ÉMILE ZOLA

L'OEUVRE

ACADÉMIE SUISSE

In 1861, Cézanne finally followed in his friend Zola's footsteps and made the move to Paris. He spent each morning from six until 11 at the Académie Suisse. The free art school was founded by Charles Suisse, a former model who had made his career sitting for painters including Jacques-Louis David and Antoine-Jean Gros. Here, in a ramshackle building on the corner of the Quai des Orfévres and the Boulevard du Palais on the Île de la Cité, artists were provided with models in a liberal setting without formal tuition, for a small monthly fee. Cézanne came into contact with several influential artists – most significantly Camille Pissarro, with whom he would form a symbiotic working relationship and loyal friendship. Who were some of the other alumni?

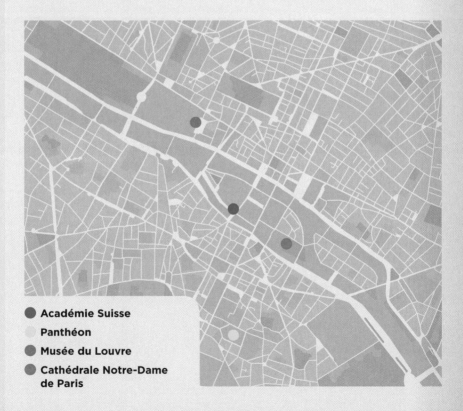

● Académie Suisse
● Panthéon
● Musée du Louvre
● Cathédrale Notre-Dame
 de Paris

ACADÉMIE SUISSE ALUMNI

GUSTAVE COURBET (1819–77)

EUGÈNE DELACROIX (1798–1863)

HONORÉ DAUMIER (1808–79)

ACHILLE EMPÉRAIRE (1829–98)

ARMAND GUILLAUMIN (1841–1927)

ÉDOUARD MANET (1832–83)

CLAUDE MONET (1840–1926)

CAMILLE PISSARRO (1830–1903)

PAUL CÉZANNE (1839–1906)

MADAME CÉZANNE

Cézanne met Marie-Hortense Fiquet at the Académie Suisse in 1869. She became his partner, his model, the mother of his child and, after some time, his wife. Their relationship was strained and the two became emotionally distanced, separating in later life. Hortense has been cited as a difficult woman, though it is true that Cézanne could also be a difficult man, insisting on keeping their relationship unknown to his family for many years and prone to bouts of anxiety and depression. What do we know about Madame Cézanne?

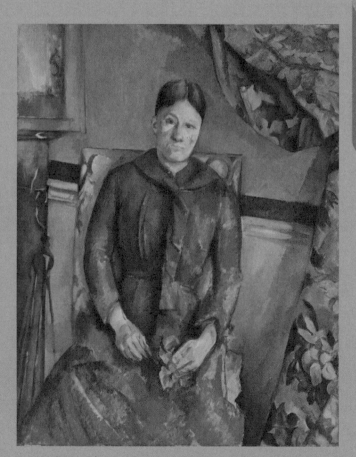

Hortense worked as a bookbinder, and earned extra money as a part-time model.

Their only son Paul was born in

1872

▲ *Madame Cézanne in a Red Dress*
Paul Cézanne
Oil on canvas, 1888–90
46 x 35 inches (117 x 90 cm)

9 The number of years Cézanne kept their relationship a secret from his father, for fear of a cut to his allowance.

17 The number of years they were unmarried, becoming betrothed on 28 April 1886. By this time Cézanne had publicly stated that he had lost feelings for Hortense, and he moved in with his mother shortly after they were married.

29 The number of portraits Cézanne painted of Hortense, from 1872 until the early 1890s when the two became estranged.

Cézanne disinherited Hortense, leaving his entire estate to their son Paul.

THE END OF A FRIENDSHIP

Émile Zola was Cézanne's best friend and, as Alex Danchev has commented: "the main axis of his emotional life from cradle to grave." In 1886, he published the novel *L'Oeuvre* (*The Masterpiece*), in which the central character, Claude Lantier, is a brilliant artist doomed to failure. After receiving a copy of the book and recognizing several parallels between his own life and that of Lantier (and also between Zola and the character Pierre Sandoz) he was deeply hurt. Cézanne returned the book along with a final letter that was full of feeling, cutting all ties with his old friend.

EXCERPT FROM L'OEUVRE

The break between Claude and his friends had slowly widened. His painting they found so disturbing, and were so conscious of the disintegration of their youthful admiration that little by little they had begun to fall away ...

Claude had somehow lost his foothold and, as far as his art was concerned, was slipping deeper and deeper into madness, heroic madness ...

LETTER FROM CÉZANNE TO ZOLA

Gardanne
4 April 1886

My dear Émile,

I've just received *L'Oeuvre* which you were kind enough to send me. I thank the author of the Rougon-Macquart for this kind token of remembrance and ask him to allow me to press his hand with the memory of old times.

Ever yours, with the feeling of time passing,

Paul Cézanne

CÉZANNE IN LATER LIFE

1899 Victor Chocquet's art collection is sold and Cézanne's paintings fetch up to ...

4,000 FRANCS EACH

He exhibits at the Salon des Indépendants. The family estate, Jas de Bouffan, is sold.

1890 Cézanne begins work on a series of paintings featuring card players. He is diagnosed with diabetes, which causes him much anguish.

1891 He is living in Aix with his mother, whilst Hortense and his son Paul stay close by.

1894 In February, Ambroise Vollard purchases four works, and Galerie Durand-Ruel acquires two for the first time. Cézanne spends September in Giverny, where Monet holds a gathering in his honour.

1897 Cézanne's mother dies. The National Gallery in Berlin acquires one of his works. Vollard buys the contents of Cézanne's studio.

ANNE ÉLISABETH HONORINE CÉZANNE (1814–97)

1895 Ambroise Vollard stages an exhibition of Cézanne's work; Monet, Renoir and Degas are among the buyers. It is a commercial success and his reputation in Paris starts to grow. He increasingly begins to work in isolation.

LAND FOR SALE

1906 Cézanne is suffering from constant headaches, leaving his son to run the business side of his work. In October, Cézanne is caught out in a storm and dies just over a week later.

1901 He purchases some land at Les Lauves, an area to the north of Aix.

1902 Émile Zola dies and Cézanne mourns his passing, despite their estrangement. He builds his studio at Les Lauves.

1904 In February, Émile Bernard stays with Cézanne. In June, he writes that he is suffering from "cerebral disturbances". In October, a whole room at the new Salon d'Automne is dedicated to his work.

1903 Exhibits in Vienna, Paris and Berlin. Camille Pissarro (below) dies.

A TEMPESTUOUS END

On 15 October 1906, Cézanne was caught in a thunderstorm while painting in a field. Trying to escape the storm, he collapsed and was taken home by a passing laundryman. The following day, though severly weakened, he continued to work on a portrait of his gardener. Suffering from pneumonia, Cézanne was subsequently confined to bed for his final days, getting up intermittently to add touches to a watercolour (*Still Life with Carafe, Bottle and Fruit*) before passing away.

DATE:
22 OCTOBER 1906

AGE:
67

CAUSE OF DEATH:
PNEUMONIA

LOCATION OF DEATH:
AIX-EN-PROVENCE

RESTING PLACE:
SAINT-PIERRE CEMETERY, AIX-EN-PROVENCE

"*I HAVE SWORN MYSELF TO DIE PAINTING.*"
—Paul Cézanne, letter to Émile Bernard, 21 September 1906

PAUL CÉZANNE

02
WORLD

"WITH AN APPLE, I WANT TO ASTONISH PARIS!"

—Paul Cézanne, on his still-life painting, quoted in *Claude Monet: Sa Vie, Son Temps, Son Oeuvre* by Gustave Geffroy, 1922

CÉZANNE'S PROVENCE

LA MARGUERITE

A viewpoint from which Cézanne painted many scenes of the Montagne Sainte-Victoire.

Landscape
Home/studio
Painting location
Town

AIX-EN-PROVENCE

BELLEVUE

A property high on a hill close to the house of his sister Rose. It was one of several locations outside of Aix that he began to paint after 1885.

JAS DE BOUFFAN

The family estate. An 18th-century manor house on the outskirts of Aix. Cézanne decorated the grand salon with murals, painted its chestnut tree-lined avenue and built a studio there. It was sold in 1899.

L'ESTAQUE

A small fishing village. Cézanne would return repeatedly to capture the Mediterranean light and colour on canvas, defining his constructive brushstroke technique.

LES LAUVES

Cézanne's studio.
Located to the north of Aix, Cézanne acquired the plot of land in 1901, and subsequently built a studio there in order to paint the surrounding countryside.

FRANCE

BIBÉMUS

An abandoned quarry dating back to Roman times. Cézanne rented a cabin nearby from around 1895 to paint the quarry and nearby landscapes of Le Tholonet in complete isolation.

LE THOLONET

CHÂTEAU NOIR

An old house near the Bibémus quarry. Cézanne started to paint in the grounds in around 1900.

▲ *Château Noir*
Paul Cézanne
Oil on canvas, 1900/04
29 x 38 inches (74 x 97 cm)

MONTAGNE SAINTE-VICTOIRE

Cézanne first painted the mountain, which is steeped in local legend, in 1870. It would become his greatest motif.

GARDANNE

Cézanne spent the winter of 1885–6 in Gardanne with Hortense and his young son. He would continue to paint the town, drawn to the geometry of its architecture and the surrounding landscape.

WORLD

MES CONFIDENCES

Based on a popular parlour game at the time,
Mes Confidences, asked questions to which
Cézanne offered the following answers:

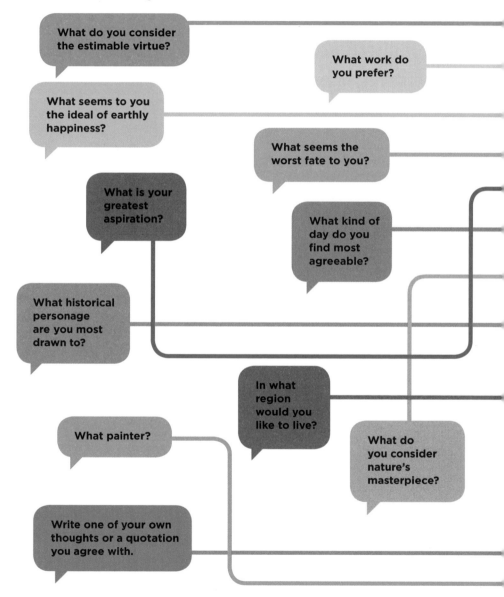

What is your
favourite colour?

What do you consider
the estimable virtue?

What work do
you prefer?

What seems to you
the ideal of earthly
happiness?

What seems the
worst fate to you?

What is your
greatest
aspiration?

What kind of
day do you
find most
agreeable?

What historical
personage
are you most
drawn to?

In what
region
would you
like to live?

What painter?

What do
you consider
nature's
masterpiece?

Write one of your own
thoughts or a quotation
you agree with.

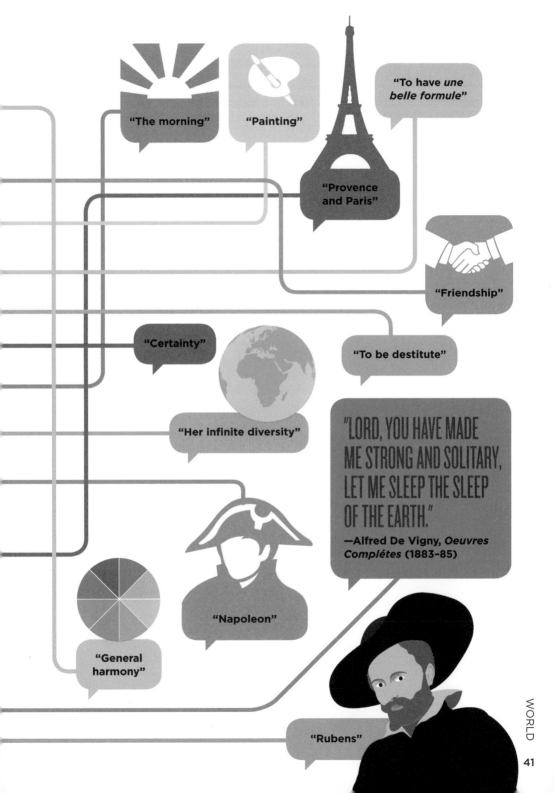

"The morning"

"Painting"

"To have *une belle formule*"

"Provence and Paris"

"Friendship"

"Certainty"

"To be destitute"

"Her infinite diversity"

"LORD, YOU HAVE MADE ME STRONG AND SOLITARY, LET ME SLEEP THE SLEEP OF THE EARTH."
—Alfred De Vigny, *Oeuvres Complétes* (1883–85)

"Napoleon"

"General harmony"

"Rubens"

COURTING REJECTION

In 1863, Cézanne participated in the Salon des Refusés, where revolutionary artists including Manet, Pissarro and Monet exhibited work previously rejected by the Paris Salon. Cézanne went on to submit entries to the official Salon, writing to Pissarro, in 1865, that they would "make the Institute turn red with rage and despair". Consistently rejected each year from 1864 to 1869, and from 1876 to 1879, the independent and anti-establishment Cézanne saw each entry as an opportunity to rail against convention. He was finally accepted by the back door in 1882 by listing himself as a "pupil of M. Guillemet" – the name of a friend who was serving on the jury.

1865 ✗

▶ **Still Life with Bread and Eggs**
Paul Cézanne
Oil on canvas
1865
23 x 30 inches
(59 x 76 cm)

Cézanne's first notable attempt at the still-life genre, imbued with the brooding palette of his Dark Period.

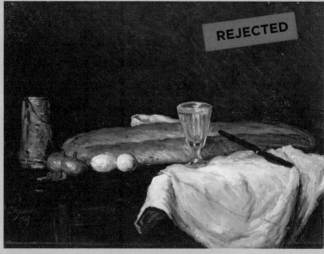

REJECTED

1866 ✗

▶ **Antony Valabrègue**
Paul Cézanne
Oil on canvas
1869–71
46 x 39 inches
(116 x 98 cm)

A palette-knife portrait which caused one juror to comment that it appeared to be "painted with a pistol."

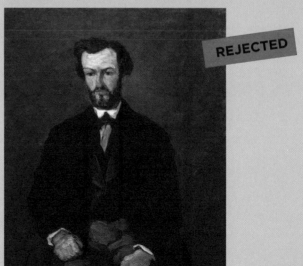

REJECTED

"INSTITUTIONS, STIPENDS AND HONOURS ARE MADE ONLY FOR IDIOTS, PRANKSTERS AND ROGUES ... I DON'T GIVE A DAMN."

—Paul Cézanne, quoted in *En Écoutant Cézanne, Degas, Renoir* by Ambroise Vollard, 1938

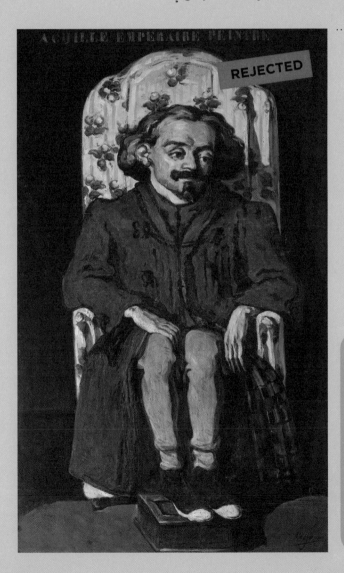

REJECTED

1870 ✗

◀ *Achille Empéraire*
Paul Cézanne
Oil on canvas
1867–70
79 x 48 inches
(200 x 121 cm)

Cézanne gives stately stature to friend and fellow painter Achille Empéraire, a dwarf who was also born in Aix.

1882 ? ✓

Portrait of M. L. A.

Unknown, but possibly *The Artist's Father, Reading "L'Événement,"* 1866

ACCEPTED

Camille Pissarro was the lynchpin of the Impressionist group. His fellow artists referred to him as *Père Pissarro* (Father Pissarro), in acknowledgement of his role as a guardian and advisor, and he encouraged Cézanne in the face of critical rejection and ridicule. The two painters shared a deep affinity in their life and work – how do they measure up?

MOST EXPENSIVE WORK

The Card Players (1892–6). Sold in 2011 for over $259m.

INFLUENCES

Eugène Delacroix, Nicolas Poussin, Gustave Courbet and Peter Paul Rubens.

DIED 1906

67

MARRIAGE & CHILDREN

THEMES

Landscapes, still lifes, portraits, bathers and figure compositions.

BORN 1839

45

YEARS WORKED

CAMILLE PISSARRO

MOST EXPENSIVE WORK
Boulevard Montmartre, Matinée De Printemps (1897). Sold in 2014 for £19.7m.

MARRIAGE & CHILDREN

INFLUENCES
Jean-Baptiste-Camille Corot, Gustave Courbet and Jean-François Millet.

THEMES
Landscapes, peasants at work, everyday rural life and Parisian street scenes.

DIED 1903

73

BORN 1830

51

YEARS WORKED

DEIFYING DELACROIX

Cézanne revered Eugène Delacroix, painting six copies after the Romantic master's work. Delacroix's use of colour and his expressive brushstroke were revolutionary, inspiring many 19th-century artists. Cézanne's admiration manifested itself in a lifelong desire to pay homage to the great painter after his death in 1863. The beginnings of *The Apotheosis of Delacroix* can be traced back to this time, though the final oil was to remain unfinished. Delacroix is shown in a Provençal landscape rising to heaven, surrounded by adoring worshippers based on other characters Cézanne held in high esteem – but who are they?

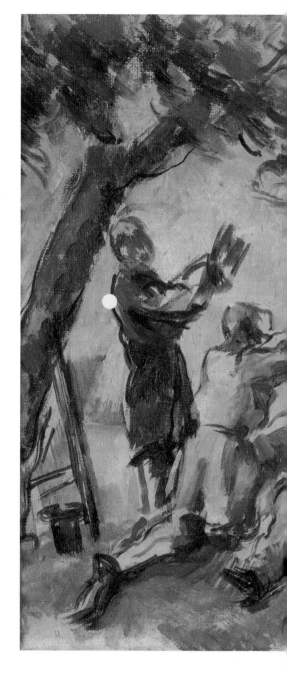

Eugène Delacroix: Shown resting on a cloud and flanked by angels. One of the angels is carrying his palette and brushes.

Camille Pissarro: Cézanne's mentor and friend. Shown at work at his easel under the shade of a tree.

Claude Monet: Pictured under an umbrella. Cézanne once said: "Monet, as I see it, is the most gifted painter of our age."

Victor Chocquet: Cézanne's early champion, friend and patron. Depicted under a tree with his top hat on the floor behind him.

Paul Cézanne: The artist, shown from behind with his walking stick and satchel of art materials. He is accompanied by a dog.

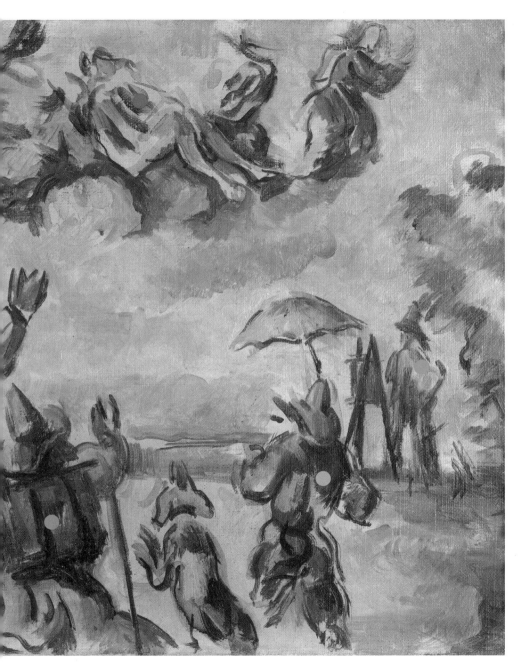

▲ *The Apotheosis of Delacroix*
Paul Cézanne
Oil on canvas, 1890–4
11 x 14 inches (27 x 35 cm)

COLLECTORS & DEALERS

Cézanne's fellow artists were the earliest collectors of his work. This encouraged interest from the art supplier Julien Tanguy, who would accept paintings in lieu of payment for materials, and the collector Victor Chocquet. But it was dealer Ambroise Vollard who would elevate Cézanne's reputation and make him a commercial success. After staging a solo exhibition in 1895 and buying up a high proportion of his output, he would go on to make a significant return on his investment.

WHO ACQUIRED CÉZANNE'S WORK?

KEY ■ artist ■ dealer ■ collector

6
PAUL
GAUGUIN

14
CLAUDE
MONET

7
EDGAR
DEGAS

4
AUGUSTE
RENOIR

19
CAMILLE
PISSARRO

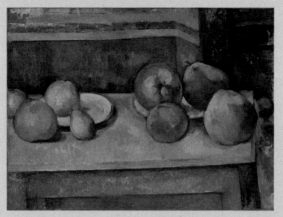

▲ **Still Life with Apples and Pears**
Paul Cézanne
Oil on canvas, c. 1891–2
18 x 23 inches (45 x 59 cm)

A HEALTHY RETURN

Art dealer Ambroise Vollard bought the artwork for:

150 francs

In 1900, he sold the piece to art buyer Heilbuth for:

2,000 francs

36

VICTOR CHOCQUET

27

JULIEN TANGUY

AMBROISE VOLLARD 670

A LOVE OF TREES

Cézanne had an affinity with trees, especially the majestic pines of his native Provence. His love for all things arboreal produced some of his most famous motifs, with trees appearing as both the central subject and as a framing device in his work. When he built his studio in his final years, he took trouble to protect a small olive tree growing in the grounds by erecting a wall around it; reportedly speaking to it, touching it and sometimes kissing it.

"IT'S A LIVING BEING, I LOVE IT LIKE AN OLD FRIEND. IT KNOWS EVERYTHING ABOUT MY LIFE AND OFFERS ME EXCELLENT ADVICE. I SHOULD LIKE TO BE BURIED AT ITS FEET."

—Paul Cézanne on the olive trees at Les Lauves, quoted in *Cézanne* by Joachim Gasquet, 1921

"DO YOU REMEMBER THE PINE THAT STOOD ON THE BANK OF THE ARC, LOWERING ITS LEAFY HEAD OVER THE CHASM THAT OPENED AT ITS FEET? THAT PINE PROTECTED OUR BODIES WITH ITS FOLIAGE FROM THE HEAT OF THE SUN, AH! MAY THE GODS PRESERVE IT FROM THE FATAL BLOW OF THE WOODCUTTER'S AXE."

—Paul Cézanne, letter to Émile Zola, 9 April 1858

CHESTNUT

An avenue of chestnut trees at Jas du Bouffan became a recurrent motif in Cézanne's work, featuring in at least 15 paintings.

PINE

OLIVE

PAUL CÉZANNE

03
WORK

"ART HAS A HARMONY WHICH PARALLELS THAT OF NATURE."

—Paul Cézanne, quoted in *Cézanne* by Joachim Gasquet, 1921

STYLES OF WORK

DARK PERIOD: 1861–70

This period is characterized by a dark palette and themes that were sometimes violent or erotic. Cézanne applied thick layers of paint, often with a palette knife, which is now seen as looking ahead to 20th-century Expressionism.

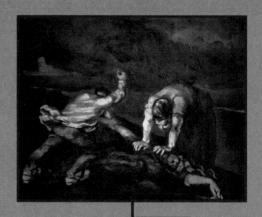

The Murder ▶
Paul Cézanne
Oil on canvas, c. 1870
26 x 32 inches (65 x 80 cm)

1839

IMPRESSIONIST PERIOD: 1870–8

Working with Pissarro encouraged Cézanne to lighten and brighten his palette and adopt looser brushwork, with landscapes becoming his central theme. During this time he exhibited twice with the Impressionists, in 1874 and 1877.

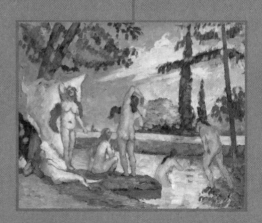

Bathers ▶
Paul Cézanne
Oil on canvas, 1874–5
15 x 18 inches (38 x 46 cm)

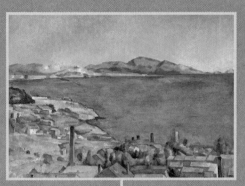

MATURE PERIOD: 1878–90

Now based in Provence, Cézanne began to concentrate on geometry, surface and colour, honing his constructive brushstroke technique. A series of paintings of Montagne Sainte-Victoire and Gardanne, made during this time, have also become known as his Constructive Period.

◀ *The Gulf of Marseilles Seen from L'Estaque*
Paul Cézanne
Oil on canvas, c. 1885
29 x 40 inches (73 x 100 cm)

1906

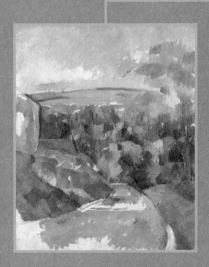

FINAL PERIOD: 1890–1906

In his final years, Cézanne would strive to realize his ambition of creating work on a grand scale. Following the building of his studio at Les Lauves, his work became infused with patches of colour.

◀ *The Bend in the Road*
Paul Cézanne
Oil on canvas, 1900–6
32 x 26 inches (82 x 66 cm)

WORK

HATS ENOUGH!

Cézanne had hats in the blood: his father had trained as a hat-maker, opening the workshop 'Cézanne and Coupin' before turning to banking. In the 1870s, hat-making was flourishing in Aix. The trade was dependent on local rabbit-farming to supply a steady stream of felt and employed some 470 men and 240 women. Over a series of 25 self-portraits, Cézanne represented himself in a range of headwear.

25 SELF-PORTRAITS

8 IN HATS

15 BALD

2 WITH HAIR

1 x BERET

1 x WIDE-BRIMMED HAT

1 x PEAKED CAP

1 x STRAW HAT

1 x FELT HAT

1 x BONNET

2 x KRONSTADT HAT

CÉZANNE'S FRUIT BOWL

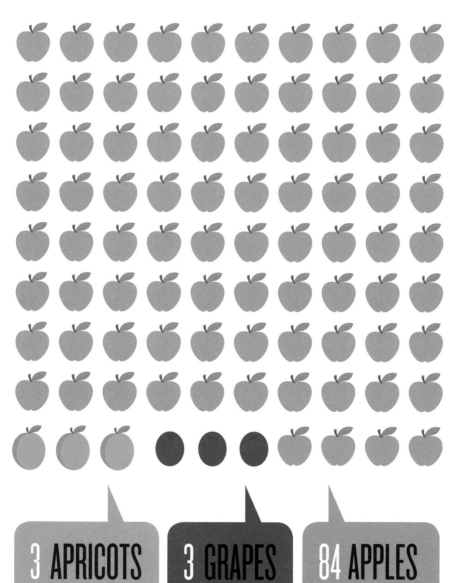

3 APRICOTS 3 GRAPES 84 APPLES

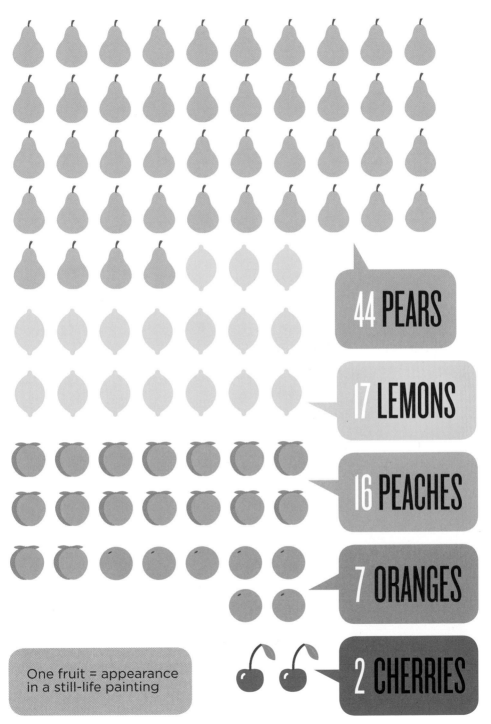

44 PEARS

17 LEMONS

16 PEACHES

7 ORANGES

2 CHERRIES

One fruit = appearance in a still-life painting

ANATOMY OF A PAINTING

The still life genre was significant in 17th-century Dutch painting, but after that time it was generally considered the lowliest subject for art. Admiring the craftsmanship of common domestic objects – and appreciating their motionless – Cézanne took it upon himself to resurrect the genre. Setting up a scene in his studio with items that would recur repeatedly in his work, the aim was not to copy them mimetically, but to analyse them from a variety of viewpoints. Objects are often pitched at different angles, creating tension, but the final canvases are balanced as a harmonious whole. This distorting of traditional one-point perspective greatly inspired Cubism in the early 20th century.

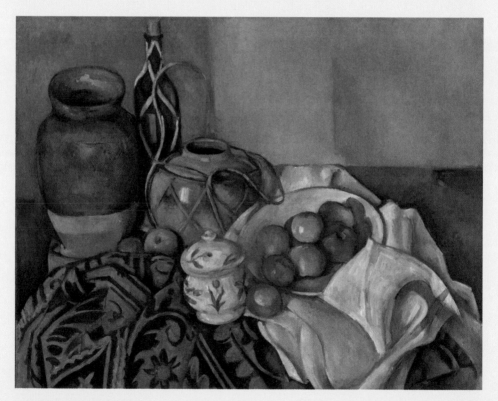

▲ *Still Life with Apples*
Paul Cézanne
Oil on canvas, 1893–4
26 x 32 inches (65 x 82 cm)

JAR, VASE AND BOTTLE

Notice how the top of the jar and vase appear to be seen from different viewpoints, and how the bottle is asymmetrical.

APPLES

Cézanne loved the spherical nature of fruit, especially apples. He would give them volume through the use of colour rather than via outlines or shadows.

BACKGROUND

The background is flat with no detail or perspective. There is a hint of a surface with a horizontal line that is lower on the left than on the right.

TABLECLOTH

Billows of geometric tablecloth give the painting structure, concealing and supporting the objects, some of which appear to be floating above it.

SUGAR BOWL

The sugar bowl in the middle of the painting is pitched at an angle, with its right-hand edge undefined, merging into the white tablecloth.

DISH

The dish appears to be floating, tipping towards a central point, and is represented from above. Compare the ellipse to those of the ginger jar and vase.

CÉZANNE PAINTED ...

44 OIL PAINTINGS AND 43 WATER-COLOURS

OF MONTAGNE SAINTE-VICTOIRE

"LOOK AT STE-VICTOIRE. WHAT ÉLAN, WHAT AN IMPERIOUS THIRSTING AFTER THE SUN, AND WHAT MELANCHOLY, OF AN EVENING, WHEN ALL THIS WEIGHTINESS FALLS BACK TO EARTH."

—Paul Cézanne, quoted in *Cézanne* by Joachim Gasquet, 1921

MOUNTAIN MAN

Cézanne's greatest motif was the Montagne Sainte-Victoire, a limestone mountain near his hometown of Aix, which he first painted in 1870. Over time he would represent it from a variety of viewpoints, sometimes combining it with his other favourite subjects such as pine trees, the Château Noir and the quarry at Bibémus. While he was working in his late style at Les Lauves his obsession reached its peak, with his canvases becoming fields of vivid colour patches, often with areas left unpainted and forms facetted.

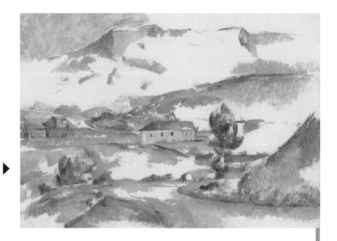

Montagne Sainte-Victoire, ▶
from near Gardanne
Paul Cézanne
Oil on canvas, c. 1887
27 x 36 inches (67 x 91 cm)

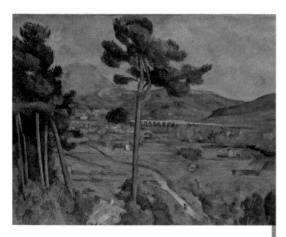

◀ **Mont Sainte-Victoire**
and the Viaduct of
the Arc River Valley
Paul Cézanne
Oil on canvas, 1882–5
26 x 32 inches
(65 x 82 cm)

1870 1875 1880 1885 1890

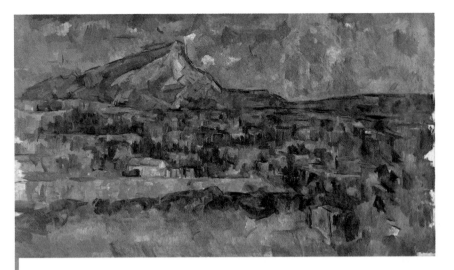

▲ *Mont Sainte-Victoire*
Paul Cézanne
Oil on canvas
c. 1902–6
23 x 38 inches
(57 x 97 cm)

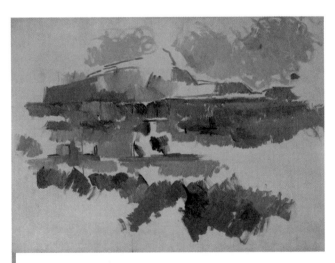

Montagne Sainte-Victoire Seen ▲
from Les Lauves
Paul Cézanne
Oil on canvas, 1904–6
21 x 29 inches (54 x 73 cm)

1895 1900 1905 1910

GEOMETRY LESSONS

Cézanne sought to represent the fundamental structure of his subjects: from his wife Hortense to an apple, and especially the landscape of his beloved Provence. His approach to constructing a painting was analytical and often laboured. It was a process of intense study and deliberation, culminating in work that explored the underlying geometry of nature.

"TREAT NATURE IN TERMS OF THE CYLINDER, THE SPHERE, THE CONE, EVERYTHING PUT IN PERSPECTIVE, SO THAT EACH SIDE OF AN OBJECT, OF A PLANE, LEADS TO A CENTRAL POINT."

—Paul Cézanne, letter to Émile Bernard, 15 April 1904

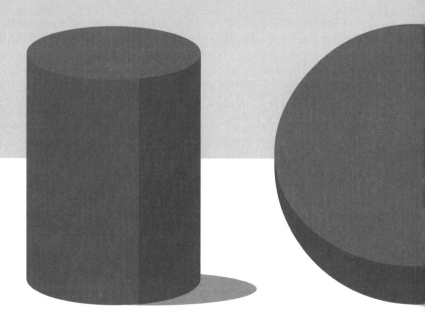

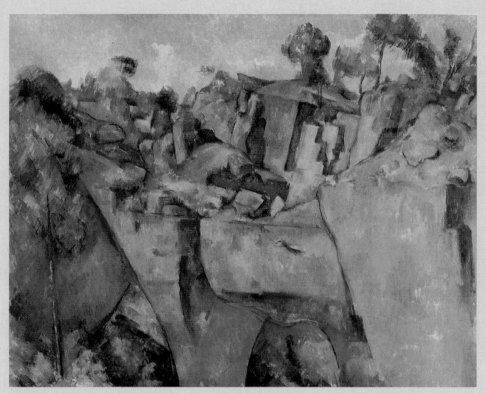

Bibémus Quarry ▲
Paul Cézanne
Oil on canvas, c. 1895
26 x 32 inches (65 x 81 cm)

THE LARGE BATHERS

In his final years, Cézanne embarked on a series of monumental paintings of bathers – a motif he had pursued throughout his career. Having been inspired by the tradition of representing nudes in a landscape, as seen in the work of Titian and Poussin, Cézanne reinterpreted the theme in a new way and on a grand scale. His last artistic testament can be seen as realizing his dream of making art that was "solid and durable, like the art of museums".

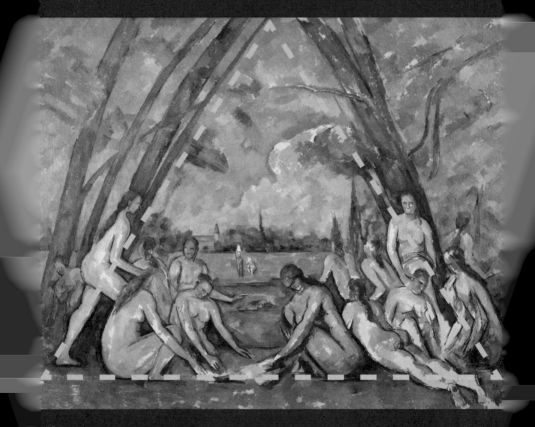

COMPOSITION

Cézanne has employed architectonic symmetry, referencing the pyramidal compositions found in Renaissance

▲ *The Large Bathers*
Paul Cézanne
Oil on canvas, 1900–6
83 x 99 inches (211 x 251 cm)

$110,000

The amount paid for the painting in 1937 by The Philadelphia Museum of Art.

3

The number of paintings in the same series. The other, smaller works are located in the National Gallery, London, and the Barnes Foundation, Philadelphia, USA.

1907

The year the painting was posthumously exhibited. Matisse and Picasso both took a strong interest, with Picasso painting Les Demoiselles d'Avignon *in the same year.*

HUMAN FORM

Cézanne has deconstructed the human body, ignoring anatomical correctness as well as classical ideas of beauty. He famously disliked painting from life models (being shy and anxious about women, but also thinking models expensive) preferring to reference earlier studies or the Old Masters.

Artwork height:
83 inches (211 cm)

Cézanne's height:
67 ⅓ inches (171 cm)

CÉZANNE'S PALETTE

YELLOWS

NAPLES YELLOW

BRILLIANT YELLOW

CHROME YELLOW

YELLOW OCHRE

RAW SIENNA

REDS

VERMILION

BURNT SIENNA

ROSE MADDER

BURNT LAKE

RED OCHRE

CARMINE LAKE

Cézanne was a master of colour who deeply understood its resonance, especially in relation to nature. By combining warm and cool tones in patches and planes, he created the illusion of depth on a canvas.

This was his palette, according to Émile Bernard:

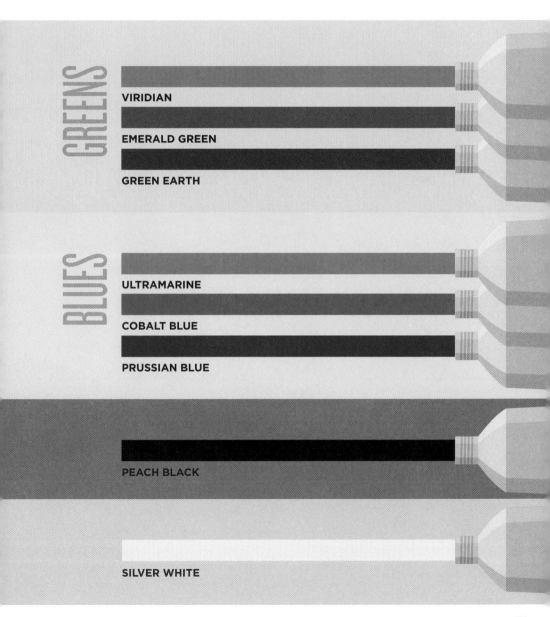

GREENS

VIRIDIAN

EMERALD GREEN

GREEN EARTH

BLUES

ULTRAMARINE

COBALT BLUE

PRUSSIAN BLUE

PEACH BLACK

SILVER WHITE

16 SHADES OF BLUE

Cézanne was once asked why he loved the colour ultramarine, replying "because the sky is blue", and he would often start a new work by washing the canvas with a diluted solution of the pigment. Others have commented on his relationship with the colour blue: Robert Bresson identified a 'Cézanne blue' and Octave Mirbeau noted that his work captures, "the blue hour in the day".

Poet Rainer Maria Rilke was fascinated by Cézanne's approach to colour, and, in a letter to his wife Clara, identified at least 16 nuanced shades of blue used by the painter.

"WE MEN EXPERIENCE NATURE MORE IN TERMS OF DEPTH THAN SURFACE, WHENCE THE NEED TO INTRODUCE INTO OUR VIBRATIONS OF LIGHT, REPRESENTED BY THE REDS AND YELLOWS, A SUFFICIENT QUANTITY OF BLUE TONES, TO GIVE A SENSE OF ATMOSPHERE."

—Paul Cézanne, letter to Émile Bernard, 15 April 1904

01	SKY BLUE
02	SEA BLUE
03	BLUE-GREEN
04	BARELY BLUE
05	WAXY BLUE
06	LISTENING BLUE
07	BLUE DOVE-GRAY
08	WET DARK BLUE
09	JUICY BLUE
10	LIGHT CLOUDY BLUE
11	THUNDERSTORM BLUE
12	BOURGEOIS COTTON BLUE
13	DENSELY QUILTED BLUE
14	ANCIENT EGYPTIAN SHADOW-BLUE
15	SELF-CONTAINED BLUE
16	COMPLETELY SUPPORTLESS BLUE

DIFFERENT STROKES

Cézanne's brushstroke evolved from the thickly applied paint of his early works – sometimes applied with a palette knife – to the daubs of Impressionism and through to the use of parallel lines. At the beginning of his Mature Period, he came to define his 'constructive brushstroke' technique whilst working in and around L'Estaque. Instead of using bigger strokes in the foreground, which diminished in size towards the background, Cézanne would regularize their size, foregoing traditional perspective and utilizing warm and cool colours to create depth instead. This technique unified the surface of his canvas and evolved into his use of colour patches in later works.

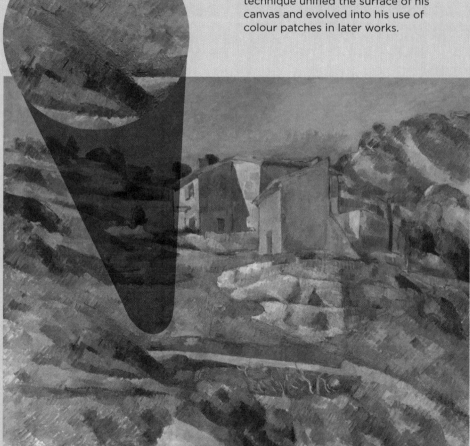

▲ *Houses in Provence: The Riaux Valley near L'Estaque*
Paul Cézanne
Oil on canvas, c. 1803
26 x 32 inches (65 x 81 cm)

PAUL
CÉZANNE

04
LEGACY

"CÉZANNE WAS LIKE THE FATHER OF US ALL."

—Pablo Picasso, 1943, quoted in *Cézanne: Father of 20th-Century Art* by Michael Hogg, 1994

A NEW GENERATION

After he died, a major retrospective of Cézanne's work was held in 1907 at the Salon d'Automne, attracting many visitors and solidifying his reputation as a visionary. Among his admirers were a new generation of artists inspired by his expressive brushstrokes, use of colour and geometric representation of space. They would take his ideas and run with them; as such Cézanne is often cited as being a bridge between Impressionism and the radical new forms of art of the 20th century.

PAUL CÉZANNE (1839–1906)

"I AM THE PRIMITIVE OF A NEW ART. I SHALL HAVE MY SUCCESSORS; I CAN SENSE IT."

—Paul Cézanne, quoted in *Souvenirs sur Cézanne* by Émile Bernard, 1925

KEY

 Post-Impressionism Fauvism Cubism

 Expressionism ● Abstract Expressionism

HENRI MATISSE
(1869−1954)

WASSILY KANDINSKY
(1866−1944)

PABLO PICASSO
(1881−1973)

ARSHILE GORKY
(1904−48)

GEORGES BRAQUE
(1882−1963)

CÉZANNE'S STUDIO

Following the sale of his family's estate, Cézanne moved to an apartment on the Rue Boulegon in Aix, the site of his father's old bank. In 1901, he purchased a plot of land known as Les Lauves for the sum of 2,000 francs, building a two-storey studio on the 7,000 square metre (0.7-hectare) plot in 1902. When he died, the successive owners maintained the studio on the upper floor exactly as he had left it. Today, it is open to the public, allowing visitors to experience the painter's world in his final years.

Hats, coat and smocks.

Various pots, bottles and jugs.

Walking cane

Three skulls from a friend who worked at the Museum of Natural History in Aix.

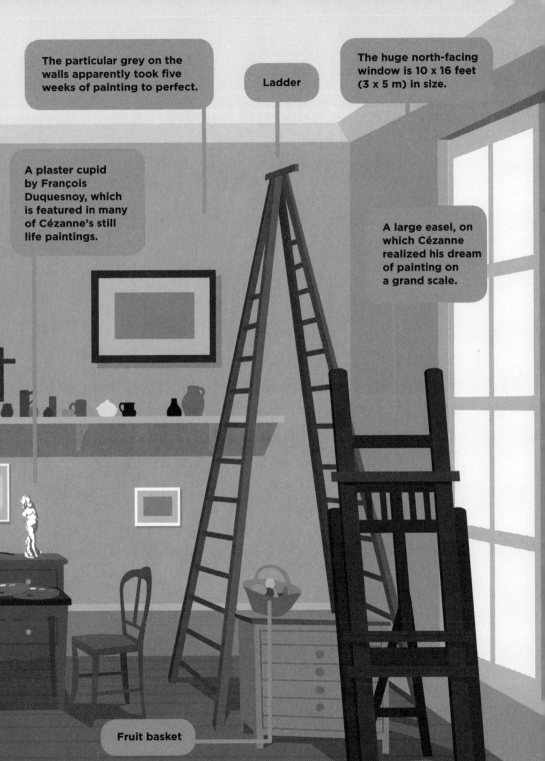

JOURNEY OF A STOLEN PAINTING

1960 ZURICH

After Bührle's death, his heirs give the painting to the Foundation E.G. Bührle Collection.

1948 ZURICH

4 Collector and patron Emil Georg Bührle acquires the painting for 400,000 Swiss francs.

1913 LANGERFELD/WUPPERTAL, MUNICH, LUGANO, ASCONA & LAUSANNE

3 Gottlieb Friedrich Reber buys the painting at the sale of Nemes' collection on 18 June for 56,000 francs. As he moves around Europe, the painting accompanies him.

1909 BUDAPEST

2 The collector Marczell de Nemes purchases *The Boy in the Red Waistcoat* from Vollard on 30 July for 20,000 francs.

1895 PARIS

Art dealer Ambroise Vollard (right) acquires the painting for 200 francs.

1888–90 I

PARIS

Cézanne paints *The Boy in the Red Waistcoat* while in Paris. It is one of four works, with the same title, featuring the Italian model Michelangelo di Rosa.

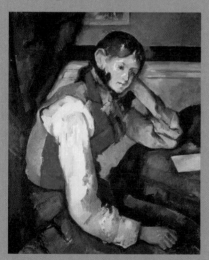

▲ *The Boy in the Red Waistcoat*
Paul Cézanne
Oil on canvas, c. 1888–90
31 x 25 inches (80 x 64 cm)

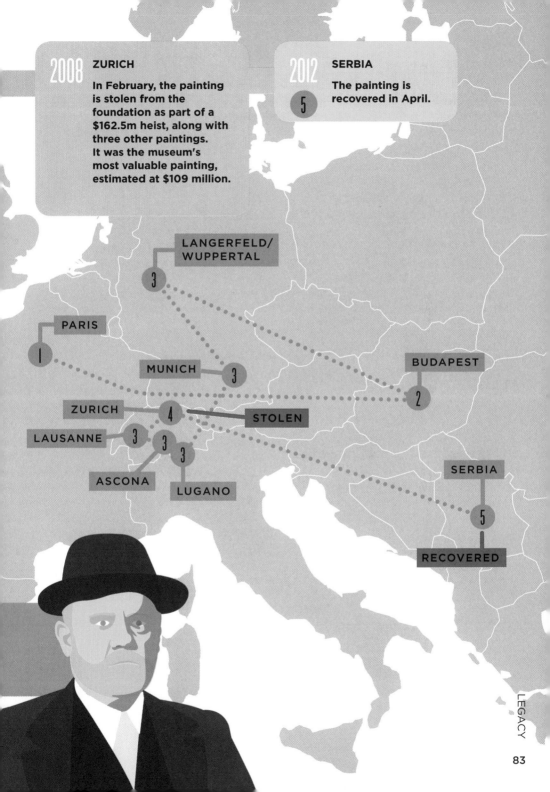

2008 **ZURICH**

In February, the painting is stolen from the foundation as part of a $162.5m heist, along with three other paintings. It was the museum's most valuable painting, estimated at $109 million.

2012 **SERBIA**

5 The painting is recovered in April.

LANGERFELD/
WUPPERTAL

3

PARIS

1

MUNICH 3

BUDAPEST

2

ZURICH 4 STOLEN

LAUSANNE 3

ASCONA 3 3

LUGANO

SERBIA

5

RECOVERED

CEZANNE BY NUMBERS

1,400 drawings (mostly from 18 sketchbooks)

645 watercolours

954 paintings

TYPOGRAPHIC CÉZANNE

geometry

Aix

Jas de Bouffan

bather

hats

apple

L'Oeuvre

Cézanne

constructive brushstroke

jug

Paris

blue

Gardanne

Delacroix

trees

Pissarro

innovator

palette knife

Post-Impressionism

fruit

Les Lauves

nature

pine

L'Estaque

colour patches

Cubism

Montagne Sainte-Victoire

still life

Picasso

Zola

Bibémus

Hortense

portrait

landscape

Bellevue

Provence

Impressionism

The Card players

Château Noir

Modernism

CÉZANNE FOR SALE

To date, Cézanne's *The Card Players* – one of a series of five paintings that explore the theme of gambling – is the third most expensive work of art ever sold. Two other paintings from his final period are not far behind: a landscape featuring Montagne Sainte-Victoire and a still life. Although the taste of younger collectors may have shifted away from Impressionism and Post-Impressionism, art experts will always revere Cézanne, and when it appears for sale his late work fetches consistently high prices.

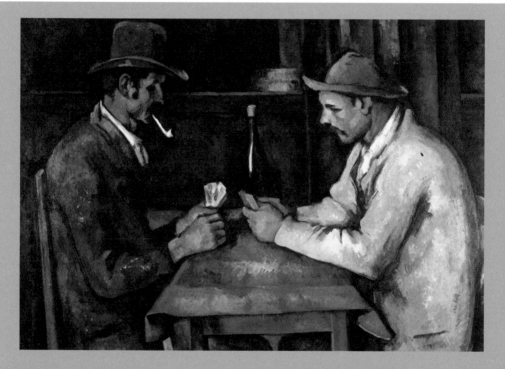

▲ **The Card Players**
Paul Cézanne
Oil on canvas, 1892–6,
38 x 51 inches (97 x 130 cm)

$259m

The Card Players
1892–6, sold 2011

La Montagne Sainte-Victoire vue
du bosquet du Château Noir
1904, sold 2013

$100m

Rideau, Cruchon et
Compotier
1893–4, sold 1999

$60.5m

LOCATING CEZANNE: PUBLIC COLLECTIONS WORLDWIDE

Cézanne's artwork is represented in numerous museums and galleries worldwide. The numbers given here are only some of the works in permanent collections, but there are many more in existence to explore as well as regular temporary exhibitions.

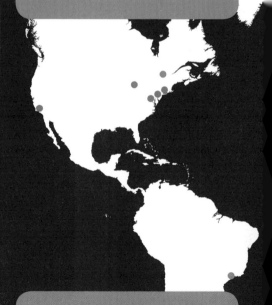

CANADA

National Gallery of Canada, Ontario
5 WORKS

USA

**Barnes Foundation
Philadelphia, Pennsylvania**
61 WORKS

**The Metropolitan Museum of Art
New York City, New York**
24 WORKS

**National Gallery of Art
Washington, D.C.**
23 WORKS

**The Museum of Modern Art
New York City, New York**
12 WORKS

**The Art Institute of Chicago
Chicago, Illinois**
10 WORKS

**J. Paul Getty Museum,
Los Angeles, California**
4 WORKS

BRAZIL

Museu de Arte de São Paulo Assis
Chateaubriand, São Paulo
5 WORKS

RUSSIA

Pushkin Museum, Moscow
14 WORKS

Hermitage Museum, St Petersburg
11 WORKS

GERMANY

Nationalgalerie, Berlin
3 WORKS

Staatsgalerie, Stuttgart
3 WORKS

UNITED KINGDOM

The Courtauld Gallery, London
9 WORKS

National Gallery, London
9 WORKS

Glasgow City Art Gallery, Glasgow
3 WORKS

National Museum, Cardiff, Wales
3 WORKS

Tate Gallery, London
3 WORKS

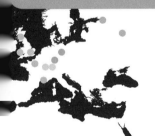

JAPAN

Pola Museum of Art, Hakone, Kanagawa
9 WORKS

Bridgestone Museum of Art, Tokyo
3 WORKS

FRANCE

Musée d'Orsay, Paris
46 WORKS

Musée de l'Orangerie, Paris,
14 WORKS

Musée Granet, Aix-en-Provence
8 WORKS

SWITZERLAND

Kunstmuseum Basel, Basel
5 WORKS

Kunsthaus Zürich, Zürich
3 WORKS

BIOGRAPHIES

Camille Pissarro (1830–1903)

As the father figure of the Impressionist group, Pissarro encouraged Cézanne's work and inspired a shift in his style. During the 1870s they frequently worked together, painting the same motifs around Pontoise.

Hortense Fiquet (1850–1922)

Hortense was 19 when she met Cézanne, working as a bookbinder and part-time model in Paris. They had a son in 1872 and would not marry until 1886, becoming psychologically and physically distant in later life.

Ambroise Vollard (1867–1939)

Important Parisian art dealer who staged a solo exhibition of Cézanne's work in 1895, bringing the artist financial reward and critical acclaim. Vollard would continue to champion the painter and released his memoirs in the 1930s.

Émile Zola (1840–1902)

Novelist and critic Zola was Cézanne's dearest childhood friend. They enjoyed an idyllic youth spent roaming the landscape around Aix, and remained close until the publication of Zola's novel *L'Oeuvre*.

Victor Chocquet (1821–91)

The biggest collector and admirer of Cézanne's early work, Chocquet worked as a customs official and was a patron to several Impressionist artists. The two became good friends and Cézanne painted his portrait.

Paul Cézanne Jr. (1872–1947)

The artist's only child enjoyed a warm relationship with his father. He helped to support his business and became his closest companion in old age. Paul Jr. was the sole heir to Cézanne's estate.

Joachim Gasquet (1873–1921)

The son of Henri Gasquet, Cézanne's schoolboy friend, Joachim befriended Cézanne in 1896. A journalist and poet, he would write several articles on the painter as well as a memoir of their time together, which both remembered with affection.

Émile Bernard (1868–1941)

A painter and writer 30 years Cézanne's junior, Bernard befriended the artist in the early 20th century, visiting him at his studio in Les Lauves. He would go on to publish a book of recollections in 1925.

Baptistin Baille (1841–1918)

One of the 'Three Inseperables', Baille met Cézanne and Zola at the College Bourbon. A talented scientist, he went on to become professor of optics and acoustics at the École de Physique et de Chimie Industrielles in Paris.

Julien "Père" Tanguy (1825–94)

A supplier of art materials, Tanguy was a champion of the avant-garde who accepted works in lieu of payment and often waived payment altogether (Cézanne's credit amounted to 4,015 francs in 1887).

Louis-Auguste Cézanne (1798–1886)

Cézanne's father was a prosperous banker. The young artist was financially dependent on Louis-Auguste, and would keep his partner, Hortense, and young son, Paul, a secret from him for several years.

Anne Élisabeth Cézanne (1814–97)

Cézanne appeared to enjoy a close relationship with his mother, about whom little is known. He moved in with her shortly after his marriage to Hortense began to sour and she often supported her son in family altercations.

● friend ● family

● business associate

INDEX

CÉZANNE'S FRUIT BOWL

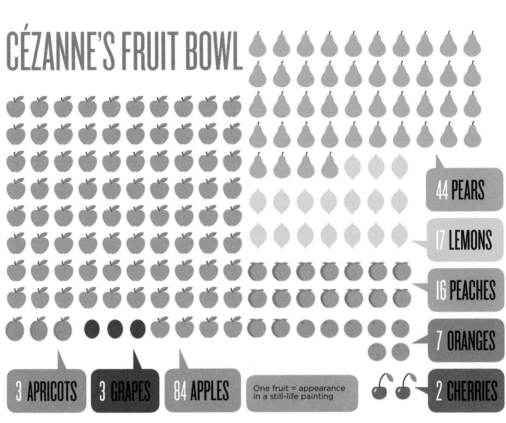

44 PEARS

17 LEMONS

16 PEACHES

7 ORANGES

3 APRICOTS

3 GRAPES

84 APPLES

One fruit = appearance in a still-life painting

2 CHERRIES